	DATE DUE		

A Kid's Guide to Drawing the Countries of the World™

How to Draw
Kenya's
Sights and Symbols

Melody S. Mis

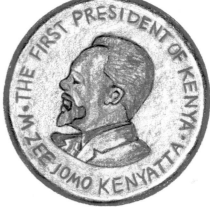

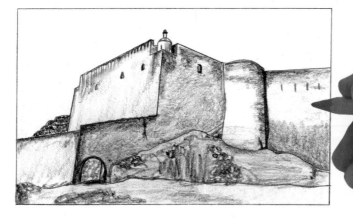

The Rosen Publishing Group's
PowerKids Press™
New York

To Eva Joyce Rhodes for being a large part of our family

Published in 2005 by The Rosen Publishing Group, Inc.
29 East 21st Street, New York, NY 10010

First Edition

Editors: Jannell Khu, Natashya Wilson
Book Design: Kim Sonsky
Layout Design: Mike Donnellan

Illustration Credits: Cover and inside by Holly Cefrey.
Photo Credits: Cover and title page (hand) by Arlan Dean; pp. 5, 16 © Royalty Free/Corbis; pp. 9, 32 © Carl & Ann Purcell/Corbis; p. 10 © Yan Arthus-Bertrand/Corbis; pp. 12, 13 courtesy of Sukuro Etale; p. 18 © Norton Beebe/Corbis; p. 20 © Vittoriano Rastelli/Corbis; p. 22 © Jonathan Blair/Corbis; p. 22 (inset) © Orban Thierry/Corbis Sygma; p. 24 © Ric Ergenbright/Corbis; pp. 26, 34 © Wolfgang Kaehler/Corbis; pp. 28, 36 Charles & Josette Lenars/Corbis; p. 30 © John Noble/Corbis; p. 38 © Joe McDonald/Corbis; p. 40 © Brian A. Vikander/Corbis; p. 42 © Wolfgang Kaehler/Corbis.

Library of Congress Cataloging-in-Publication Data

Mis, Melody S.
How to draw Kenya's sights and symbols / Melody S. Mis.— 1st ed.
 p. cm. — (A kid's guide to drawing the countries of the world)
Summary: Presents step-by-step directions for drawing the national flag, Mount Kenya, Uhuru Monument, and other sights and symbols of Kenya.
Includes bibliographical references and index.
ISBN 1-4042-2733-4 (Library Binding)
1. Drawing—Technique—Juvenile literature. 2. Kenya—In art—Juvenile literature. [1. Drawing—Technique. 2. Kenya—In art.] I. Title. II. Series.

NC655.M577 2005
743'.8996762—dc22

2003022452

Manufactured in the United States of America

CONTENTS

Let's Draw Kenya

People lived in Kenya in prehistoric times, more than two million years ago. However, Kenya's earliest recorded history began around the first century A.D., when tribes from northern and central Africa started migrating to Kenya. These tribes included the Luo, the Maasai, and the Kikuyu. They settled in central and western Kenya, where they farmed the land and raised cattle. Other tribes settled along Kenya's east coast. They traded goods with Arabs, people who are native to countries in southwest Asia and the Middle East. The tribes began to speak a language called Swahili. It became Kenya's official language.

During the eighth century, many Arabs migrated to Kenya. They built cities and controlled Kenya's coast until the sixteenth century, when Portugal invaded. The Portuguese built Fort Jesus in Mombasa. They also united, or brought together, the coastal cities, creating an empire that lasted 200 years.

In 1698, Arabs from the country of Oman drove the Portuguese out of Kenya. The Omanis ruled the east

4

Statues of elephant tusks line Moi Avenue in Mombasa, Kenya's oldest and second-most-populated city. Mombasa is located on Kenya's coast. It is an important port for trade in Kenya and Africa.

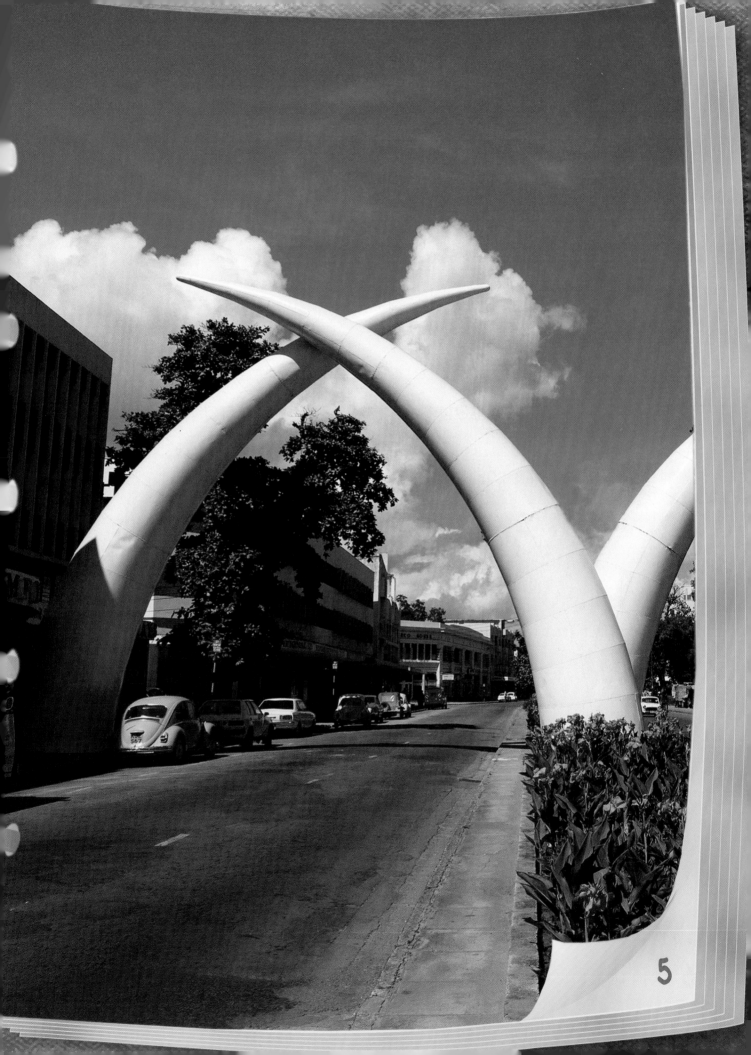

coast of Kenya for the next 150 years. They became rich by selling African slaves to French colonies. In 1822, the British forced the Omanis to sign an agreement to stop the slave trade.

In the 1880s, the British East India Company took control of Kenya. Explorers and missionaries from Britain traveled to Kenya. They wanted to claim Kenya for Britain and to convert the Kenyans to Christianity. In 1886, Kenya became a British Protectorate.

The British wanted to build a railroad across Kenya. They built the Uganda Railway through the middle of Maasai territory. When the railroad was done in 1901, white settlers moved onto Maasai lands. The Maasai were forced onto a reserve in southern Kenya. Soon whites controlled Kenyan land, government, and society. They taxed the Kenyans unfairly and banned them from public restaurants and bathrooms. A Kenyan named Jomo Kenyatta went to England to get help for his people from the British government. The British ignored Kenyatta. People from the Kikuyu tribe, who called themselves Mau Maus, started a rebellion to free Kenya from British rule. From 1952 to 1956, the Mau Maus killed many white settlers and Africans

who supported white rule. Finally, in 1963, Kenya became independent. Jomo Kenyatta was Kenya's first prime minister and president. He united Africans and whites and created a stable society.

This book will show you how to draw some of Kenya's sights and symbols. You will start with one shape and add others to it. New shapes are shown in red. Directions are printed under each step. Before you start, gather the following supplies:

- A sketch pad
- An eraser

- A number 2 pencil
- A pencil sharpener

These are some of the shapes and drawing terms you need to know to draw Kenya's sights and symbols:

—— Horizontal line

⬯ Oval

▭ Rectangle

▰ Shading

∿ Squiggly line

⬡ Trapezoid

△ Triangle

| Vertical line

∿ Wavy line

More About Kenya

Kenya is located on the eastern coast of the African continent. The equator passes through the middle of the country. With an area of 224,962 square miles (582,649 sq km), Kenya is a bit smaller than the state of Texas. Kenya's northern neighbors are Ethiopia and Sudan. Its southern neighbor is Tanzania. Uganda borders Kenya to the west. Somalia and the Indian Ocean form the eastern border.

Nairobi is Kenya's capital and most-populated city, with more than 4.5 million people. It is located in the south-central part of the country. Nairobi was founded in 1899 as a labor camp for the workers on the Uganda Railway. The railroad was nicknamed the Lunatic Line, because the land that it crossed had never been explored. To construct the railroad, the British brought 32,000 laborers from India, 28 of whom were killed on the job by lions. Mombasa is Kenya's second-most-populated city, with about 665,000 people. Located on an island just off the coast, Mombasa is the nation's largest port.

Tourists can observe the wildlife of the Maasai Mara Game Reserve from hot air balloons. The reserve was founded in 1961 and measures 720 square miles (1,865 sq km). The wildlife that can be found there include wildebeests, lions, and zebras.

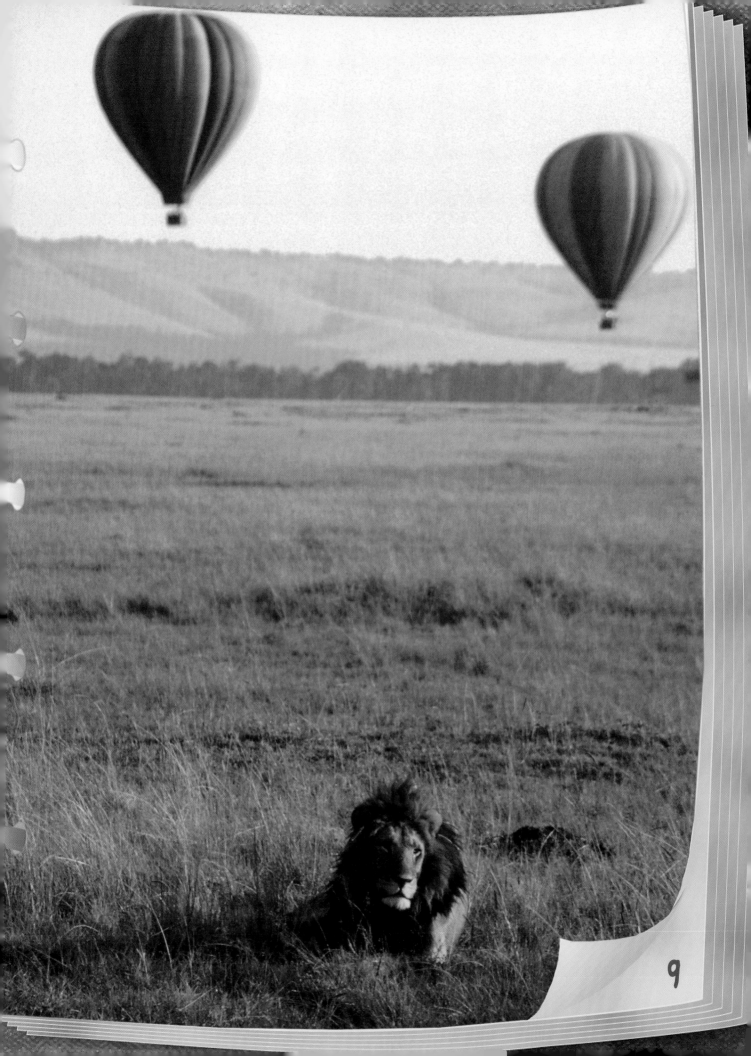

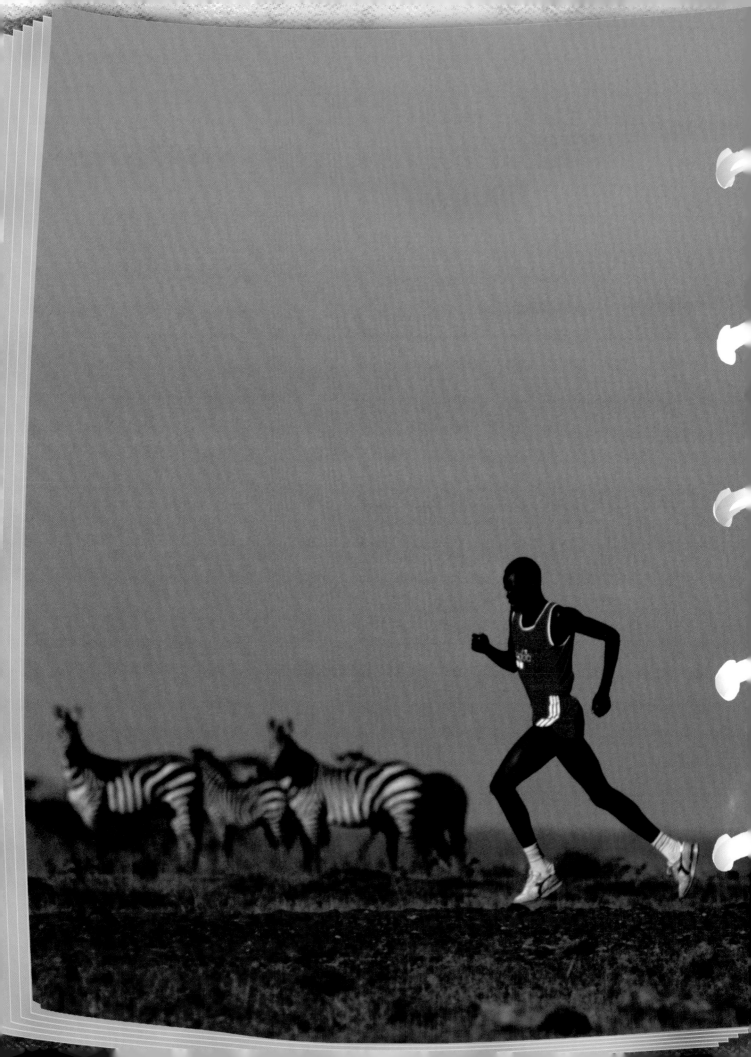

Kenya has a population of about 31 million people. Most Kenyans are descendants of the Africans who settled in the area 2,000 years ago. About 1 percent of the population is made up of Asians, Europeans, and Arabs. More than 50 percent of Kenya's people are Christians. Another 7 percent are Muslims, many of whom descend from the Arabs who settled on the coast. Many different tribal languages are spoken in Kenya. Swahili and English are the nation's official languages.

Kenya has an agricultural economy. About three-quarters of the population farms or raises goats and cattle. Kenya is the world's third-largest producer of tea. Kenya's farms also produce coffee, corn, wheat, fruit, and dairy products. Kenya's main industries are tourism and manufactured goods such as furniture, cloth, and oil products. The nation's natural resources include gold, limestone, and salt. However, the most valuable resource in Kenya is its wildlife. People from all over the world visit Kenya to see elephants, rhinos, lions, and other wild animals in their natural environment.

Punda milia is the Swahili name for zebra, and it means "striped donkey." Even though humans are considered among their enemies, along with lions and hyenas, the zebras here seem undisturbed by the passing runner.

11

The Artist
Sukuro Etale

Sukuro Etale

Sukuro Etale was born in Nairobi, the capital of Kenya, in 1954. He went to school in Tanzania, the country that borders southern Kenya. Etale got his degree in education. He taught in two high schools in Kenya between 1978 and 1980. In 1982, he established an organization called Sanaa Art Promotions. This organization promotes Kenyan art and artists. It also helps young people with behavioral problems by using art as a means of communication.

Etale has shown his paintings in exhibitions across the world. He has also written poems, short stories, and children's books. Some of his books are about the animals and plants that can be found in Kenya. Many of his paintings are of the African landscape. A landscape is a picture of natural scenery. Etale's painting shown here is

12

called *Elkeiyo Homestead*. Etale painted it because he thought the scenery was so beautiful. He called it "breathtaking." The Elkeiyo people raise cattle in the Rift Valley in northwestern Kenya. They live in round huts made of twigs and grasses that are found nearby. The Elkeiyo build their huts up in the hills so they can protect themselves and their cattle from invaders. Etale painted the Elkeiyo homesteads and hilly landscape in soft colors.

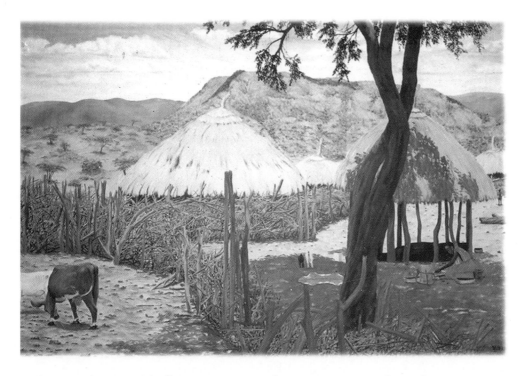

Sukuro Etale painted *Elkeiyo Homestead* in 1985. He used acrylics on canvas. The painting measures 24" by 48" (61 cm x 122 cm). The soft colors he used make the scene look very peaceful.

Map of Kenya

KENYA

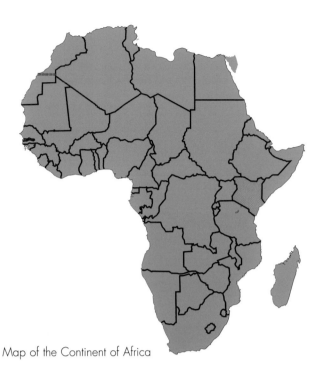

Map of the Continent of Africa

Kenya has one of the most varied landscapes in Africa. The world's second-largest freshwater lake, Victoria, lies partly in Kenya's southwest corner. East of the lake, a plateau stretches to the Great Rift Valley. Rich soil makes the plateau the country's best farming area. The Great Rift Valley has volcanoes, lakes, and snowcapped mountains. Mount Kenya, the nation's highest peak at 17,057 feet (5,199 m), is located there. Kenya's longest river, the Tana, begins at Mount Kenya and flows 440 miles (708 km) east to the Indian Ocean. The land east of the valley is mostly flat and dry. Few people live in this area. A grassy savanna covers much of southern Kenya. The nation's most popular animal parks are located there. Kenya's coast has low hills and white-sand beaches.

1

Start by drawing a rectangle. This will be your guide to drawing the map of Kenya.

2

Start Kenya's western border with a squiggly line.

3

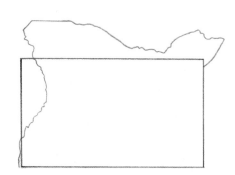

Use more squiggly lines and one short horizontal line to draw the northern part of the country.

4

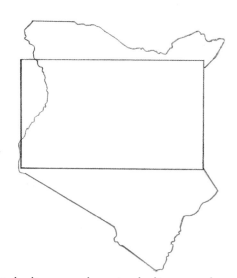

Use straight lines and squiggly lines to draw the southern part of Kenya. The right side of the rectangle will be part of the border.

5

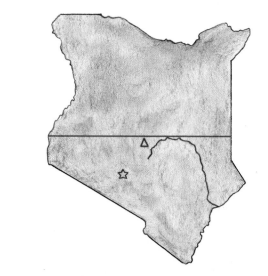

Erase the guide rectangle. Use the side of your pencil tip to shade the country. Draw a star for Nairobi. Add a squiggly line for the Tana River. Make a triangle for Mount Kenya. Add a straight line for the equator. Make a map key.

☆ Nairobi
〜 Tana River
△ Mount Kenya
— Equator

Flag of Kenya

Kenya adopted its national flag in 1963, when it became an independent country. It is based on the flag of the Kenya African National Union (KANU), which is Kenya's main political party. Kenya's flag has three horizontal stripes that are equal in width. The top stripe is black and stands for the people of Kenya. The middle stripe is red and represents the blood that Kenyans shed during their fight for independence. The bottom stripe is green. It symbolizes Kenya's natural resources and agriculture. The three large stripes are divided by narrow white stripes that stand for peace and unity. In the middle of the flag there is a shield with two spears through it. The shield is like one that a Maasai warrior would carry. It represents Kenya's defense of freedom.

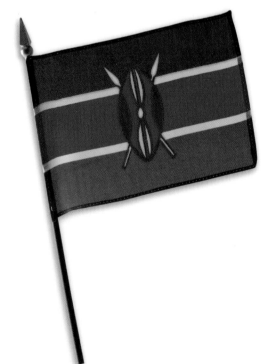

1

Start by drawing a leaning rectangle.

2

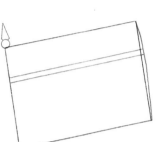

Draw a small circle and a triangle in the top left corner. Draw two straight lines inside the rectangle. Draw a curved line on the right edge of the rectangle.

3

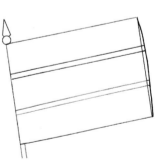

Add two more straight lines inside the rectangle. Draw two small lines on the lower left side of the flag for the pole.

4

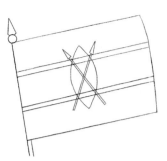

Erase the right side of the rectangle. Draw the shield and spears in the center of the flag. Make straight lines to draw the spears. The tips are small triangles.

5

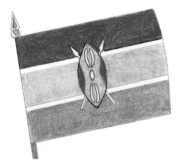

Erase the extra lines in the shield and spears. Add details to the shape in the middle as shown. Finish by shading. The top section is darkest. The middle section is lightest. The sides of the shield are dark. Notice how the thin lines you drew in steps 2 and 3 remain white. Well done! You have finished drawing Kenya's flag.

Currency of Kenya

Kenya's unit of currency is called the Kenya shilling, which is shortened to KSh. One KSh is divided into 100 cents. Coins come in denominations of 5, 10, and 50 cents and 1 KSh. The denominations of Kenya's banknotes are 10, 20, 50, 100, 200, 500, and 1,000 KSh. The banknotes come in colorful shades of blue, green, yellow, pink, and lavender. All of the notes have pictures on them. Either President Jomo Kenyatta or President Daniel Moi is pictured on one side of each banknote. On the other side of each note is a Kenyan scene. For example, one note shows people picking tea. The 10-KSh note shows students graduating from college. Another note shows Kenyan wildlife. The 20-KSh note, which features blue lions, is sometimes called the Kenya pound. It is often used to tip people who provide services to others, such as wait staff and taxi drivers.

1

Draw three circles. Notice that the outer two are spaced evenly. The center circle is slightly off-center.

2

Draw the top of President Kenyatta's suit. The curved lines make a collar, a tie, and shoulders.

3

Use curved and squiggly lines to draw the face. The chin is covered by a beard. Add lines for the ear.

4

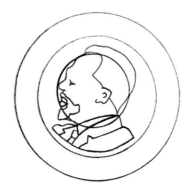

Draw curved lines for the hair. Draw small lines to show the eye. Draw a small line for the neck.

5

Erase the center circle. Begin writing the words around the outside edge of the coin.

6

Finish the words and erase the inside circle. Add an eyebrow. Finish with shading. You can make the head darker than the background. Shade the outer edge of the coin darker as well. Well done! You are finished.

Kenya's Coat of Arms

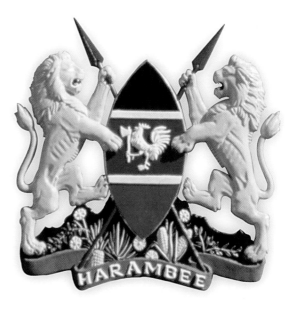

Kenya's coat of arms was adopted in 1963, when the country became independent from Britain. On the coat of arms there are two gold lions, one on either side of a Maasai shield with two crossed spears. The lions symbolize Kenya's wildlife and the courage of its people. The shield and spears represent the nation's struggle for freedom. The top section of the shield is black, symbolizing Kenya's people. The green section on the bottom represents the earth. Red is the color of the middle section. It stands for the blood of the warriors who fought for independence. In the center of the red section is a white rooster holding an ax. It is a symbol of the Kenya African National Union. *Harambee*, the word placed at the base of the coat of arms, is the national motto. It means "all pull together."

1

Draw a long vertical line. Use this guideline to help you draw things evenly on both sides. Draw two curved lines to make an almond shape. This will become the shield. Draw two straight lines that cross. These will become spears. Draw the curved shape on the bottom.

2

Erase the vertical line. Make the spears wider. Draw triangles on the tops of the spears. Draw two pairs of straight lines across the shield. Add two squiggly shapes to the ends of the curvy shape at the bottom. This will be the banner.

3

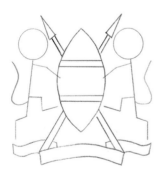

Erase the part of the spears inside the shield. Erase extra lines. Make stick figures to use as guides for the lions. Draw circles for the heads. Add straight lines for the bodies and wavy lines for the tails.

4

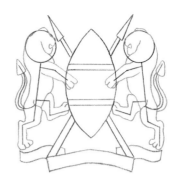

Draw the lions around the stick figures and the circles you drew in the last step.

5

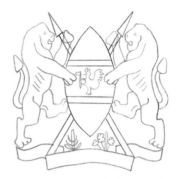

Erase the extra lines and the circle guides. Draw the back arm of each lion. The paws of the back arms hold the spears. Add the eyes and noses. Add more lines in the lions. Use curved and squiggly lines to draw the rooster and the ax in the center of the shield. Add the plants at the bottom.

6

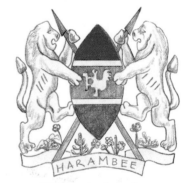

Erase any extra lines. Write "HARAMBEE" in the center of the banner. Draw more plants above the banner. Finish with shading. The top part of the shield is darkest, and the center is lightest. Shade the lions, the spears, and the plants.

Lake Turkana and the Cradle of Mankind

Kenya is called the Cradle of Mankind, because scientists believe that the ancestors of modern humans originated there. In 1968, Richard Leakey discovered the prehistoric site at Koobi Fora, located on the eastern shore of Lake Turkana in northern Kenya. Leakey is a famous archaeologist who is also known for his work to protect Kenya's wildlife. He is the son of Louis and Mary Leakey, who are famous for their discoveries of prehistoric life in Africa. At Koobi Fora, Richard Leakey uncovered the skull of *Homo habilis*, a prehistoric human who lived in the area more than two million years ago. More than 400 fossils were found at Koobi Fora. Scientists are studying them to learn how prehistoric humans lived and what they ate.

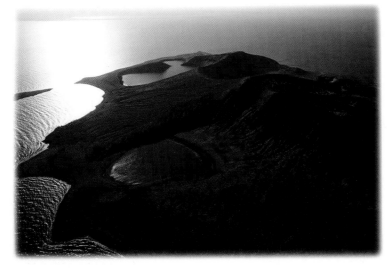

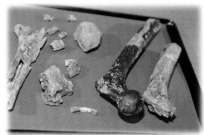

1

You are going to draw the Central Island on Lake Turkana. Begin by drawing a large rectangle.

2

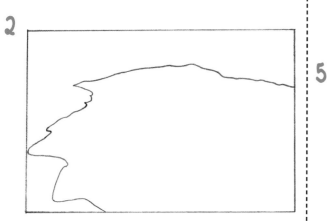

Starting at the bottom left side of the rectangle, draw a long line that juts out in several places as it travels up and across the inside of the rectangle.

3

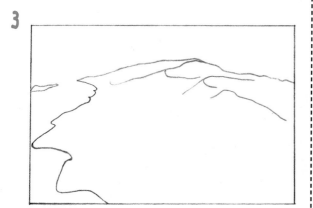

Add the small shape at the left side of the drawing. Next, draw the wavy lines inside the shape you drew in the last step. These lines are some of the hills that can be found on the island.

4

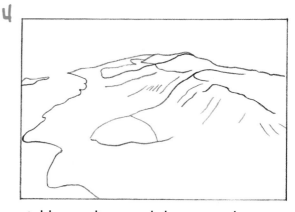

Add more lines and shapes as shown. Look carefully at the photograph on the opposite page to help you while you draw these lines and shapes.

5

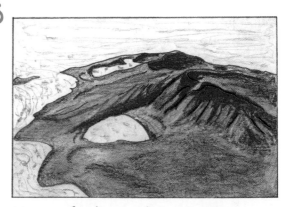

You can finish your drawing with shading. Notice how the water is lightly shaded, while the island is darker. Well done! You did a super job.

23

The Maasai People of Kenya

The Maasai are the most famous tribal people in Kenya. They are known for their bravery as warriors, their simple lives as cattle herders, and their colorful clothing. The Maasai often wear bright red clothing and many pieces of jewelry. Maasai women make the jewelry out of colorful beads.

Many Maasai are nomads who herd cattle. Nomads are people who travel from place to place. The Maasai believe that their god, Ngai, gave them all of the world's cattle to protect. The cattle provide food and symbolize a family's wealth. Cow milk is the main food of the Maasai. Sometimes they mix the milk with cow blood, because they believe the blood makes them strong.

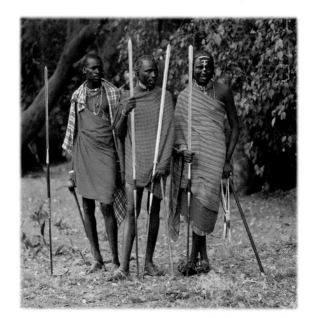

1

Draw a stick figure. The head shape is a rough oval with a narrow bottom for the chin. The hand shapes are round.

2

Draw two more stick figures. Notice the different head shapes. The left figure does not have a line for one of the arms. That arm is hidden behind the center figure.

3

Erase the vertical lines in the head circles. Begin to draw the slightly curved lines of the center body. Draw a sloping line above the knees for the robe.

4

Erase the guidelines for the center body. Finish drawing the robe. Add a necklace. Draw lines for the hands. Draw lines at the knees. Begin drawing the bodies and robes for the other figures.

5

Erase the other stick guidelines. Draw fingers on the hands of each figure. Draw the two sticks that the center and right figures are holding. Draw lines for the faces, ears, and hair. Add necklaces, jewelry, and more details to the robes.

6

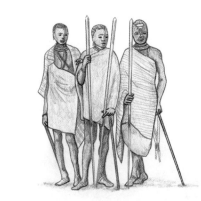

Erase any extra lines. Draw three spears and an extra stick on the left. Finish the faces, jewelry, and clothes. There are different patterns for each robe. Draw sandals. Finish with shading.

Fort Jesus in Mombasa

In 1498, Portuguese explorer Vasco da Gama was searching for a trade route to the Far East. On his voyage, da Gama came across the towns of Mombasa and Malindi on the east coast of Kenya. A few years later, Portuguese armies invaded the coastal cities and established an empire in East Africa. The Portuguese built Fort Jesus on a hill above Mombasa's harbor in 1593. The fort was made to look like a sixteenth-century castle. The walls were built at different angles so that no one could attack any wall without being seen by soldiers guarding the other walls. On the grounds of the fort is an eighteenth-century house, built by the Omanis after they conquered the Portuguese in 1698. Today Fort Jesus is a museum that houses Swahili, Arab, and Portuguese artifacts.

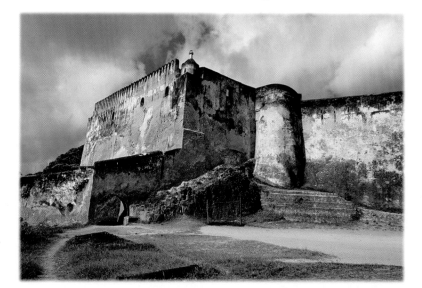

1

Begin by drawing a rectangle. Inside it, draw a horizontal line and a sloping line as shown.

2

Draw more straight lines. Notice where they cross over the lines you drew in step 1.

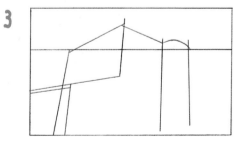

3

Looking carefully at the photograph on the opposite page, add more straight lines. Draw a curved line between the two vertical lines on the right side.

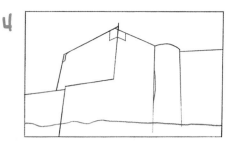

4

Erase most of the horizontal line and any extra lines. Draw a long wavy line across the bottom. Add the other lines and shapes as shown.

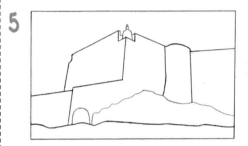

5

Erase extra lines. Draw a dome, with small lines coming from its sides, at the top of your drawing. Draw an arch for a doorway on the left side as shown. Draw a wavy line that comes from the door and goes all the way to the other side of the drawing.

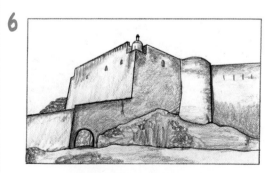

6

Look at the photograph on the opposite page and add as much detail as you like to your drawing. Finish with shading. Well done!

The Flamingos of the Great Rift Valley

The Great Rift Valley is about 4,000 miles (6,437 km) long. It stretches from the Dead Sea in the Middle East through Egypt and Kenya all the way to Mozambique, which is located south of Tanzania. The rift is so large that it can be seen from the Moon. It was formed more than 20 million years ago when the ground lifted and split. The valley is bordered on both sides by walls that are from 100 to 4,000 feet (30–1,219 m) tall. In the valley are a series of soda lakes. They have very salty water. One of these lakes, Lake Nakuru, is known for the millions of pink flamingos that flock there to eat the plants living in the lakes. The algae they eat, called spirulina, makes them turn pink! Flamingos eat with their heads upside down. They grow to be 5 feet (1.5 m) tall.

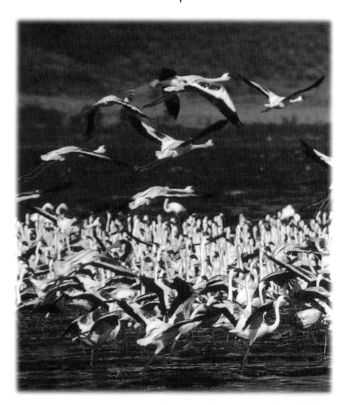

1

Draw a large rectangle. Add a horizontal line near the top of the rectangle. Along the horizontal line, draw the beginning of a flamingo. Add another flamingo at the bottom.

2

Add details, such as wings, beaks, and legs to the birds you just drew. Add the beginning of a bird at the top and at the bottom.

3

Erase part of the horizon line. Erase extra lines. Add more details to the flamingos you have already drawn. Add two more birds at the top of the drawing.

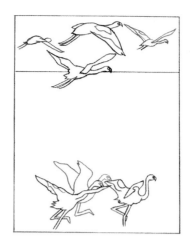

4

Erase extra lines. Add more details to three of the birds at the top of the drawing. Add more details to the one at the bottom left. Draw another flamingo behind the two at the bottom. As you can see, we have selected a few of the flamingos at the front, rather than drawing the hundreds that appear in the photograph! If you would like to add more, you can do so. Use the photograph to help you.

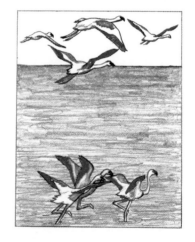

5

Erase extra lines. You can finish your picture with shading. Notice that the shading is darker in some parts. Leave the sky white. You are finished. Well done!

Mount Kenya

Mount Kenya, located north of Nairobi, is the highest mountain in Kenya and the second-highest mountain in Africa. Mount Kenya has three main peaks, the tallest of which is 17,057 feet (5,199 m) high. Some scientists think that millions of years ago the mountain was more than 23,000 feet (7,010 m) high and that its weight made it sink into the earth.

Mount Kenya is an extinct volcano, which means it is no longer active and cannot erupt. A volcano is a mountain that has holes in it. The holes allow the gas, ash, and liquid rock called lava that are hidden below the surface of the volcano to explode into the air.

Mount Kenya is the home of the Kikuyu tribe. The mountain's name comes from the Kikuyu name Kere Nyaga, which means "mountain of whiteness." That is a good description of Mount Kenya, because it is always covered with snow.

1

Begin by drawing a large rectangle. Inside the rectangle, draw the top of a triangle. These are your guidelines for drawing the mountain.

2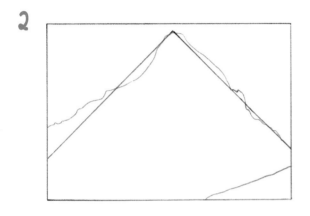

Use the guidelines to make the sides of the mountain with squiggly lines. Add a sloping line in the bottom right corner.

3

Erase the guidelines inside the rectangle. Add a squiggly line that goes from the left side of the mountain to the top part of the right side.

4

Draw three short lines on the right side of the mountain as shown.

5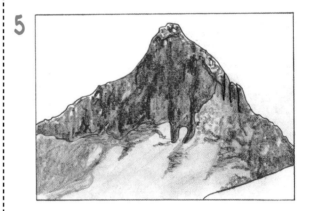

You can finish your drawing with shading. Notice how the top parts of the mountain are dark. The bottom area is light to show snow. Well done!

31

Jomo Kenyatta

Jomo Kenyatta is called the Father of Kenya. He led the nation in its struggle for freedom from Britain. Kenyatta was born in 1889 into a Kikuyu family. His Kikuyu name was Kamau

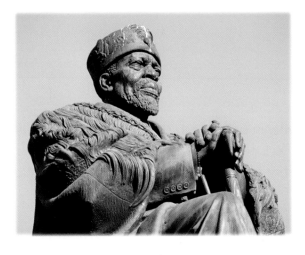

wa Ngengi. He later changed it to Jomo Kenyatta. *Jomo* means "burning spear." *Kenyatta* is a Kikuyu term for a fancy belt that Jomo wore. In 1947, he became the leader of the Kenya African Union (KAU), which was later renamed the Kenya African National Union (KANU). Kenyatta and the KAU fought British rule by organizing protests and workers' strikes. The British arrested Kenyatta. When he was released from jail in 1961, he went to London to fight for Kenya's independence. Kenya became a free country in 1963. Kenyatta was elected its first president in 1964. He gave back to Africans much of the land that the Europeans had taken. He also provided free schooling for Kenya's children.

1

Begin by drawing a rectangle. Inside the rectangle, draw a circle. Under the circle, draw curved lines to make a body shape as shown.

2

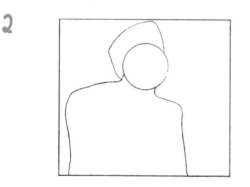

Draw a hat shape on top of the circle.

3

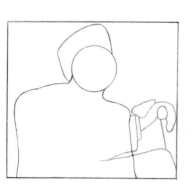

Draw lines and shapes for the arm, hands, knee, and cane on the right side of your drawing.

4

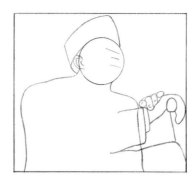

Draw three short, straight lines in the circle for guides to drawing the eyes, nose, and mouth. Draw the ear. Add the fingers to the top hand.

5

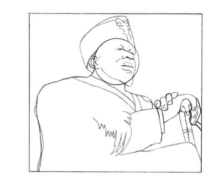

Erase extra lines. Add shapes for the eyes, nose, mouth, chin, and cheek as shown. Add fingers to the other hand. Add details to the hat, cane, and clothing of the statue.

6

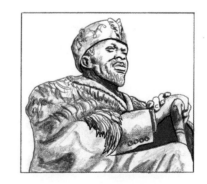

Erase the rest of the guidelines. Draw circles for the buttons on the jacket. Use squiggly and wavy lines to add decoration to the clothing. Look at the photograph to help you. You can finish your drawing with shading.

Safaris of Kenya

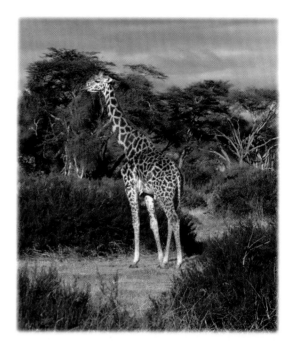

Kenya is the world's most famous place for safaris. In Swahili, safari means "travel." To most people, it means taking a trip to see wild animals in their natural environment. Years ago, rich people took hunting safaris so that they could kill rare animals and have them stuffed as trophies. When Kenyans realized how valuable their wildlife was, they banned hunting. Today people go on safari to look at and to photograph the animals in Kenya's two dozen parks. Some of Kenya's parks are small and feature rare animals, such as the blue monkey. The most famous parks, such as Maasai Mara, Tsavo, and Amboseli, are home to some of the biggest and deadliest animals on Earth. Amboseli National Park is popular because it is home to large herds of elephants and has views of Mount Kilimanjaro, Africa's highest mountain. The mountain looks as if it is nearby, but it is actually located 30 miles (48 km) away in Tanzania.

1

Begin by drawing a rectangle. Inside it, draw two circles that overlap. Add a small circle above them. Connect it to the middle circle with a line. Add lines below the bottom circle.

2

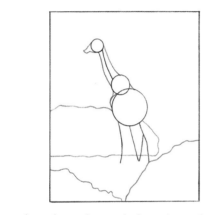

Draw head, neck, and chest lines for the giraffe. Add squiggly lines to the rest of the drawing as shown. These are bushes.

3

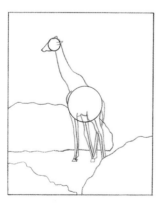

Erase the guideline for the neck and the circle guide in the middle. Draw curved lines for the legs and body. Draw the tail. Add a horn and an ear on the top of the head.

4

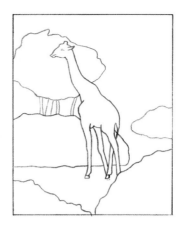

Erase the guidelines for the head, body, and legs. Add the eye and the mouth. Use squiggly and curved lines to add trees in the background. Add another shape for a bush on the right.

5

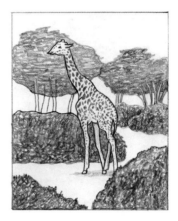

Add another bush and some more trees at the right side of your drawing. Make dark spots on the giraffe's body. Use squiggly lines to shade the trees. Finish with shading. Nice work!

The Wildebeest Migration

One of the most memorable sights in Africa is the yearly wildebeest migration. The wildebeest measures about 45 to 55 inches (114–140 cm) at the shoulder and weighs about 350 to 550 pounds (159–249 kg). Wildebeests live in the Serengeti Plain, a flat, grassy area that stretches from Tanzania to the Maasai Mara Game Reserve in southern Kenya. In late spring nearly two million wildebeests migrate north from Tanzania to the grassy Maasai Mara. Thousands of lions, cheetahs, and hyenas also come to hunt the wildebeests. By July, the wildebeests reach the Mara River, where many drown or are eaten by crocodiles. In November, the wildebeests travel back south to Tanzania.

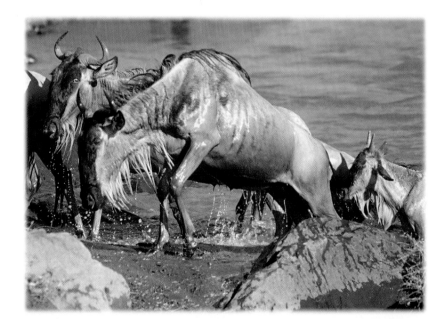

1

Begin by drawing three circles. The middle circle is large. The outer circles are smaller.

2

Draw lines around the circles for the body and head. Add straight lines as guides for the legs. Draw a squiggly line at the bottom right corner for a rock.

3

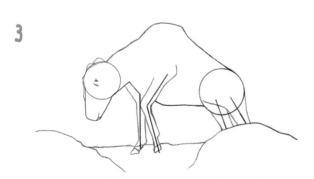

Erase most of the center circle. Draw three small bumps on top of the head. Add the eye and the mouth. Use the guidelines to draw the legs. Make sure you add hooves. Draw a squiggly line for another rock on the left. Draw a horizontal line to show the shore.

4

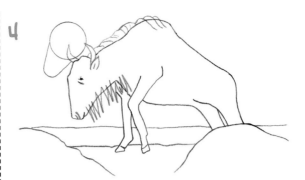

Erase the other circles and the leg guidelines. Erase any extra lines. Add the fur, the ears, a nostril, and the horns. Draw a line for the water. Draw guides for another wildebeest's head.

5

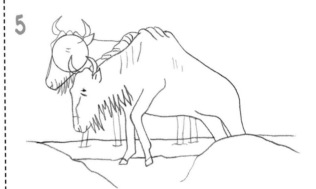

Erase extra lines around the first wildebeest's fur. Add more lines to his head and body as shown. Add lines to the second wildebeest's head. Add legs for the second wildebeest. Draw lines where its legs touch water.

6

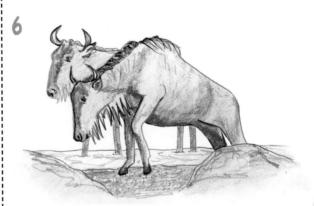

Erase extra lines. Finish with shading. The bodies are dark under the belly and on top of the heads and necks. The hooves are dark, too.

Tsavo National Park and the Umbrella Tree

Tsavo National Park is the largest animal park in Kenya. It covers 13,049 square miles (33,797 sq km). The park is famous for its wildlife, which includes lions, elephants, and hippos. It was also the home of the man-eating lions that killed workers on the Uganda Railway. The railway divides the park into two sections called West Tsavo and East Tsavo. West Tsavo is made up of valleys, plains, springs, and mountains. East Tsavo is mostly flat grassland dotted with small forests of acacia trees. There are several types of acacia. The one that symbolizes Kenya is called the umbrella tree. It is named for its shape, which is a result of giraffes eating the leaves off the tree's lower branches. The sticky sap from the acacia tree is used to make paints and glue.

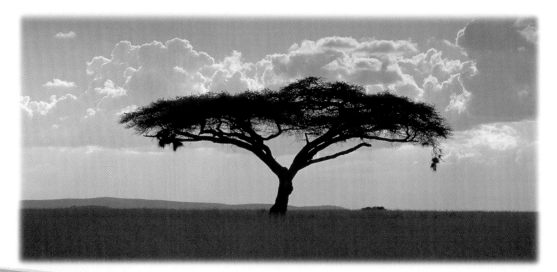

1

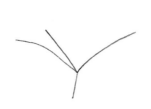

Begin by drawing the lines as shown. These will be your guidelines to drawing the umbrella tree.

2

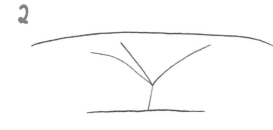

Draw a long curved line above the lines you drew in step 1. Draw a shorter line at the base of the tree guidelines.

3

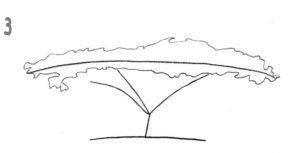

Around the long line you drew in step 2, add the squiggly shape shown. This is the leafy part of the tree.

4

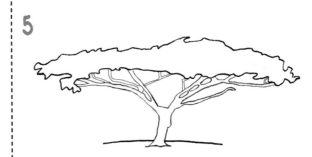

Erase the guideline at the top of the tree. Next draw the lines around the guidelines you drew in the first step. The guideline at the bottom is to help you draw the trunk. The three above this are to help you draw the branches.

5

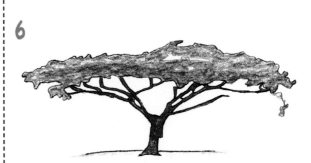

Erase the guidelines. Add extra branches.

6

You can finish your drawing with shading. Notice how the shading is darker at the trunk and branches and lighter at the leafy part. Good job!

Bomas of Kenya

In 1971, the government of Kenya created Bomas of Kenya, an outdoor museum in Nairobi, to preserve the cultures of Kenya's native people. *Bomas* is the Swahili word for "African homestead." The museum has traditional homesteads to show the lifestyles of eleven tribes, including the Luo, Maasai, Kikuyu, and Kamba. To build their homesteads, the tribes use materials that they find nearby. For example, the Maasai use twigs and tree branches to form their small homes. They cover the branches with a mixture made of grasses and mud or cow dung. The museum also has tribal dancing. Every day the world-famous Harambee dancers perform the traditional dances of many Kenyan tribes.

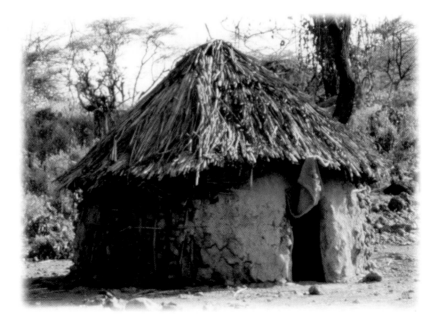

1

Begin by drawing a trapezoid. This will become the plastered walls of the bomas you are going to draw.

2

Draw the curved roof shape as shown. Bomas roofs are made with branches, grass, and other natural materials. Mud and cow dung are used to make the materials stick together.

3

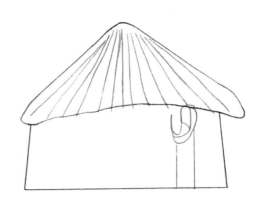

Erase the top of the trapezoid. Add a doorway and the shape of the cloth that hangs over the door. Draw the sloping lines on the roof.

4

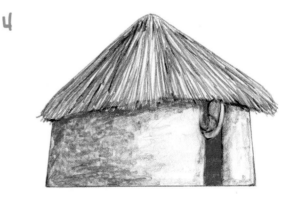

Finish with shading. Look at the photograph on the opposite page to help you. Notice how the lines on the roof stick out slightly at the bottom so that they look like grass. The doorway is very dark. You are finished. Well done!

Nyayo Monument

In 1978, Vice President Daniel Moi became president after the death of Jomo Kenyatta. The new Moi era was called *Nyayo*, which means "footsteps" in Swahili. This was because Moi promised the people of Kenya that he would follow in Kenyatta's footsteps. Where Kenyatta helped strengthen Kenya, though, Moi's leadership brought unrest and controversy.

One of the controversial things Moi did during his rule was to build monuments and other projects which were expensive. These projects cost the Kenyan people a lot of money. One such monument was the Nyayo Monument in Central Park in Nairobi. It was built in 1988 to celebrate 25 years of independence and cost nearly $1 million. At the top of the monument is a representation of the president's hand holding a club, as it pushes out through the top of Mount Kenya.

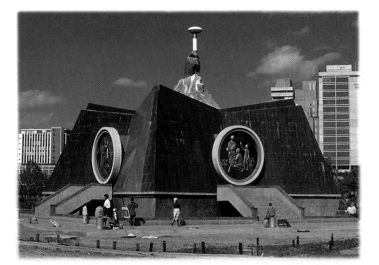

1

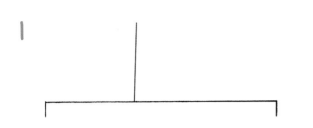

Draw a long horizontal line and a vertical line that slopes to the right very slightly. Add two short vertical lines at the ends of the horizontal line.

2

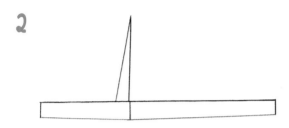

Draw a short vertical line below the horizontal line. Add three straight lines at slight angles as shown.

3

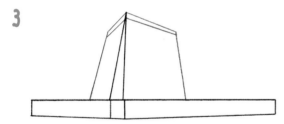

Draw more straight lines at slight angles to make the shape of the building. Add another short vertical line below the horizontal line.

4

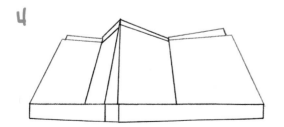

Add more straight, sloping lines at the sides to finish the basic shape of the monument.

5

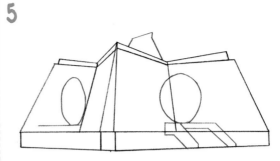

Draw two rough ovals for the doorways. Use straight lines to begin drawing the steps below the ovals. Draw the shape on top of the roof.

6

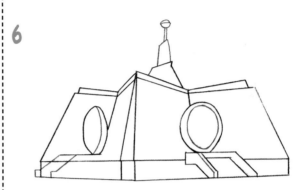

Erase extra lines. Draw the curved lines inside the ovals. Add lines to the left set of steps. Add a line in the right steps. Draw shapes on top of the roof.

7

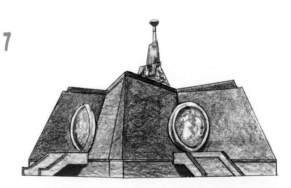

Erase extra lines. Looking at the photograph, add as much detail as you like. Finish with shading. Notice that the shading is lighter in some parts. Well done! You are finished drawing the Nyayo Monument.

Timeline

2,000,000 B.C.	Ancestors of modern man are living in Kenya.
A.D. 100s	Tribes from northern and central Africa migrate to Kenya.
700–900	Arabs trade with Kenya's East Coast tribes.
700–1500	Arabs control the east coast of Kenya.
1498	Portuguese explorer Vasco da Gama comes across the east coast of Africa.
1593	The Portuguese build Fort Jesus in Mombasa.
1698	The Omanis beat the Portuguese. The Omanis' 150-year rule over the East Coast of Kenya begins.
1822	The British force the Omanis to stop the slave trade.
late 1800s	European explorers and missionaries flock to Kenya.
1886	Kenya becomes a British Protectorate.
1889	Jomo Kenyatta is born.
1895–1901	Britain builds the Uganda Railway.
1907	Nairobi becomes the capital of Kenya.
1947	Kenyatta is chosen as leader of the Kenya African Union.
1948–1951	Kenyatta campaigns for Kenya's independence.
1952–1956	The Mau Mau Rebellion occurs.
1953	Kenyatta is arrested and imprisoned.
1961	Kenyatta is released from prison and goes to London to plead for Kenya's independence.
1963	Britain grants independence to Kenya. Kenyatta is chosen as Kenya's prime minister.
1964	Kenya becomes a republic. Kenyatta becomes president.
1978	Kenyatta dies and Daniel Moi becomes president of Kenya.

Kenya Fact List

Official Name	Republic of Kenya
Area	224,962 square miles (582,649 sq km)
Population	31,000,000
Capital	Nairobi
Most-Populated City	Nairobi, population 4,500,000
Industries	Tourism, furniture, cloth, oil products
Agriculture	Tea, coffee, corn, wheat, fruit, dairy products
Natural Resources	Wildlife, gold, limestone, salt, precious gems
National Motto	*Harambee*, or "All Pull Together"
Highest Mountain Peak	Mount Kenya, 17,057 feet (5,199 m)
Longest River	Tana River, 440 miles (708 km)
National Holiday	December 12, Independence Day
Official Languages	Swahili and English

Glossary

agricultural (a-grih-KUL-chuh-rul) Having to do with farms and farming.

algae (AL-jee) Plantlike living things without roots or stems that live in water.

ancestors (AN-ses-terz) Relatives who lived long ago.

archaeologist (ar-kee-AH-luh-jist) A person who studies the past by digging up old objects.

artifacts (AR-tih-fakts) Objects created and produced by humans.

Christianity (kris-chee-A-nih-tee) A faith based on the teachings of Jesus Christ and the Bible.

commemorates (kuh-MEH-muh-rayts) Remembers with a celebration.

continent (KON-tin-ent) One of Earth's seven large land masses.

convert (kun-VERT) To change from one religious belief to another.

cultures (KUL-churz) The beliefs, practices, art, and religion of groups of people.

denominations (dih-nah-meh-NAY-shunz) Grades of value in money.

descendants (dih-SEN-dents) People born of a certain family or group.

dung (DUNG) Animal waste.

economy (ih-KAH-nuh-mee) The way a country or a business manages its resources.

empire (EM-pyr) A large territory controlled by one ruler.

environment (en-VY-ern-ment) All the living things and conditions of a place.

equator (ih-KWAY-tur) An imaginary line around Earth that separates it into two parts, northern and southern.

fossils (FAH-sulz) The hardened remains of dead animals or plants.

independent (in-dih-PEN-dent) Free from the control of others.

industries (IN-dus-treez) Businesses in which many people work and make money producing particular products.

invaded (in-VAYD-ed) Entered a place in order to attack and take over.

lunatic (LOO-na-tik) Foolish, crazy.

materials (muh-TEER-ee-ulz) What things are made of.

migrating (MY-grayt-ing) Moving from one area to another.

missionaries (MIH-shuh-ner-eez) People who are sent to do religious work in another country.

Muslims (MUZ-lumz) People who practice the Islamic faith.

native (NAY-tiv) Born in a certain place or country.

natural resources (NA-chuh-rul REE-sors-ez) Things in nature that can be used by people.

originated (uh-RIH-juh-nayt-ed) Came from.

plateau (pla-TOH) A broad, flat, high piece of land.

political (puh-LIH-tih-kul) Having to do with the work of government or public affairs.

prehistoric (pree-his-TOR-ik) Referring to the time before written history.

preserve (prih-ZURV) To keep something from being lost or destroyed.

protectorate (pruh-TEK-tuh-ret) A country that is dependent on another country for governmental leadership.

rebellion (ruh-BEL-yun) A fight against one's government.

represents (reh-prih-ZENTS) Stands for.

savanna (suh-VA-nuh) An area of grassland with few trees or bushes.

slaves (SLAYVZ) People who are "owned" by other people and forced to work for them.

society (suh-SY-eh-tee) A group of people who have something in common.

symbols (SIM-bulz) Objects or pictures that stand for something else.

tourism (TUR-ih-zem) A business that deals with people who travel for pleasure.

traditional (truh-DIH-shuh-nul) Usual; done in a way that has been passed down over time.

tribes (TRYBZ) Groups of people who share the same customs, language, and relatives.

volcanoes (vol-KAY-nohz) Openings in the surface of Earth that sometimes shoot up a hot liquid rock, called lava.

Index

Web Sites

Due to the changing nature of Internet links, PowerKids Press has developed an online list of Web sites related to the subject of this book. This site is updated regularly. Please use this link to access the list:

www.powerkidslinks.com/kgdc/kenya/